GIFTED

The Tale of
10 Mysterious
Book Sculptures

GIFTED

to the City of
Words and Ideas

Polygon

This edition published in Great Britain in 2013 by Polygon, an imprint of Birlinn Ltd, West Newington House, 10 Newington Road, Edinburgh EH9 1QS
www.polygonbooks.co.uk

Edwin Morgan, 'A Trace of Wings' from *Themes on a Variation* (Manchester: Carcanet Press, 1988), reprinted by permission of the publisher; Norman MacCaig, 'Gifts' from *The Poems of Norman MacCaig*, edited by Ewen McCaig (Edinburgh: Polygon, 2005), reprinted by permission of the publisher.

The publishers acknowledge investment from Creative Scotland towards the publication of this volume.

ISBN: 978 1 84697 276 8
British Library Cataloguing-in-Publication Data
A catalogue record for this book is available on request from the British Library.

Design by Teresa Monachino.
Printed and bound in Spain.

Thanks to Summerhall, Edinburgh for their kind support.

CONTENTS: INTRODUCTION 6

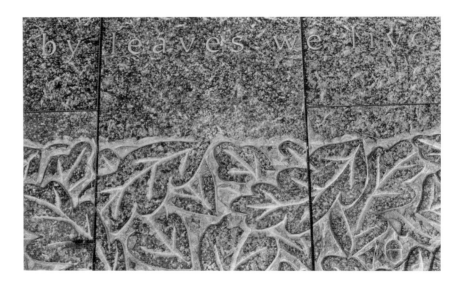

THE STORY begins with a tree growing out of a book. It begins in the Scottish Poetry Library, where the phrase by Patrick Geddes, 'by leaves we live', is carved on the threshold. It's a story about gifts, and it echoes Geddes's conclusions:

> The world is mainly a vast leaf-colony, growing on and forming a leafy soil, not a mere mineral mass, and we live not by the jingling of our coins, but by the fullness of our harvests. This is a green world, with animals comparatively few and small, and all dependent upon the leaves. By leaves we live.

The Scotsman Patrick Geddes (1854-1932) was an extraordinary combination of vision and practicality, who wrote about economics, sociology, history, art, museums, exhibitions, politics, literature, agriculture, gardening, geology, religion, philosophy, education, geography, science, astronomy, biology, planning, printing, mathematics, navigation, travel, public health, housing, music, and poetry. An environmentalist ahead of his time, a town-planner in Edinburgh and India, he understood the inter-connectedness of the world's species, and he worked to two mottos: 'By creating, we think' and 'By living, we learn'.

The book sculptures given to Edinburgh are works in Geddes's spirit, making new connections, moving us to wonder but also to think. The craftsmanship is astonishing, and it is placed in the service of 'books, words, ideas…'. The way the whole series grew is a story of call and response, a very creative interchange between an anonymous sculptor – whose declared wish is to remain so, which we respect – and a vast audience, many of whom have never seen the sculptures in their place, but only online.

It seems fitting to add a book, because all the institutions involved in this story are committed to print in some way, and because homage to the book – to that ever compact and portable friend of ideas – is central to this sculptor's series. The fortunate institutions are mostly situated in Edinburgh's Old Town, the historic heart of the city with its many connections to book-making, print, arts and crafts, the spread of ideas: the Scottish Poetry Library, the National Library of Scotland, the Filmhouse, the Scottish Storytelling Centre, Edinburgh International Book Festival (which annually pops up in Charlotte Square, in the centre of the New Town), Edinburgh UNESCO City of Literature Trust, Edinburgh Central Library, the Writers' Museum, the National Museum of Scotland.

There was one last sculpture, for world-famous Edinburgh author Ian Rankin, whose novels are set in the lovely and the less lovely streets of this city, the first designated UNESCO City of Literature. Rankin's novels, and his presence on Twitter, were the inspirations for the series. Edinburgh is the city of Jekyll and Hyde, of darkness around and within the Enlightenment spaces, and those contrasts are drawn on by the sculptor, too: hidden delights, and some hidden terrors coming into the light. The closer you look, the more you see.

Artists are inspired, supported and encouraged by organisations such as those to whom these sculptures were given, who cherish their work and want to share it. Modern technology allows us to do this ever more effectively – audience reaction on Twitter encouraged this artist in paper to make a whole series. But the heart of the thing is the artist's imagination, and dreaming how to make the impossible, possible.

These paper works have moved us not only because of their exquisite and intelligent craft, their tribute to what we all try to nurture and share, but also because they are the purest of gifts, unrequested and anonymous. They remind us that we are a community that can dream,

and nudge the impossible into another realm. As the poet Emily Dickinson wrote, 'We dwell in possibility, a fairer house than prose...' In this book we celebrate 'the fullness of our harvest' in the country of the imagination: the gifts of the imagination know no borders.

Robyn Marsack
Director, Scottish Poetry Library

Note: The publishers are very grateful to the sculptor for allowing them to make this book, and for her text and sketches – all comm-unication with her has been anonymous, and she has waived all fees. The Scottish Poetry Library is deeply grateful for her request that 50p from the sale of each book should go to the Library.

1

In March 2011, when the first shoots of spring growth were appearing in Scotland, the Librarian found a gift on a table in the Scottish Poetry Library: an old book with a tree growing out of it; sculpted from paper; an eggshell of poems; and a card which read: 'It started with your name *@ByLeavesWeLive* and became a tree... We know that a library is so much more than a building full of books... a book is so much more than pages full of words... This is for you in support of libraries, books, words, ideas...'

The SPL is not very easy to find, tucked down Crichton's Close off the Canongate, next to the massive Tun building where Scottish Courage once brewed its beers. It opened its purpose-built premises there in 1999, having been located further up the Royal Mile since its beginnings in 1984. It is a building full of books, but also full of light, a space for exhibitions and live events, for quiet reading, and for noisy visits by schoolchildren. And on the threshold, carpeted in stone oak leaves, you will see those words by Patrick Geddes: 'by leaves we live'. The sculpture was extraordinary in its delicate construction, and in its carefully considered, inspired references to the Scottish Poetry Library.

Not only did the sculptor work with books, and with the SPL's hashtag, but also with its particular collection. In 2009 the SPL opened its Edwin Morgan Archive, a large collection of printed material and ephemera by Scotland's then National Poet – or Scots Makar – and the most distinguished and well-loved poet of his generation. Morgan had written a typically playful yet serious tribute to a great Modernist poet of Northumbria, Basil Bunting. Using an Anglo-Saxon form, he made a punning yet deeply affectionate poem, naming the various kinds of bunting – a species described on the RSPB website as resembling finches, with 'simple, unmusical but distinctive songs' – and ending with the poet's name. This is the poem the sculptor reproduced as one song-line, linking the tree to the gilded eggshell, and dropping into the shell where it also forms the lining.

A TRACE OF WINGS Edwin Morgan

Corn Bunting	*shy but perky; haunts fields; grain-scatterer*
Reed Bunting	*sedge-scuttler; swayer; a cool perch*
Cirl Bunting	*small whistler; shrill early; find him!*
Indigo Bunting	*blue darter; like metal; the sheen*
Ortolan Bunting	*haunts gardens; is caught; favours tables*
Painted Bunting	*gaudy flasher; red, blue, green; what a whisk!*
Snow Bunting	*Arctic flyer; ghost-white; blizzard-hardened*
Basil Bunting	*the sweetest singer; prince of finches; gone from these parts*

Morgan too, by the time the sculpture appeared, had 'gone from these parts'.

This story would spread by virtual means: appropriately, through the Library's tweet *@ByLeavesWeLive*, the blog, and through the photographs posted by Chris Scott on the website Central Station. Soon there was a feature in the Edinburgh *Evening News* and another in *The Guardian*, and people across the world responded online to the loveliness of the thing itself and the idea of the anonymous giver.

www.scottishpoetrylibrary.org.uk

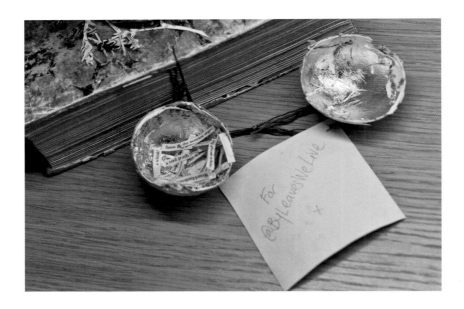

The gilded eggshell with its lines by Edwin Morgan in praise of Basil Bunting.

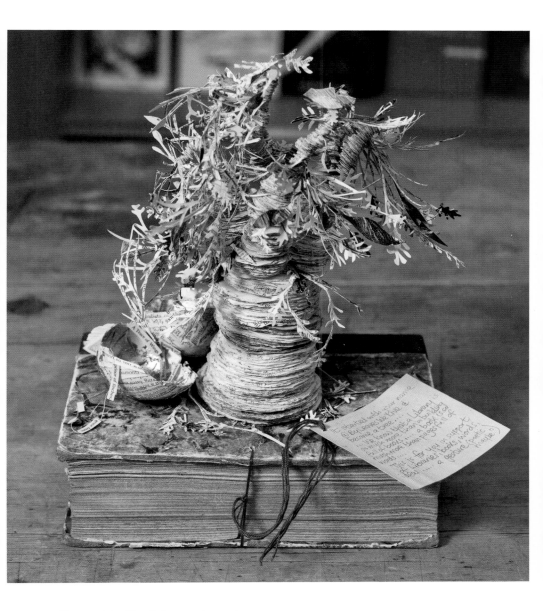

The complete gift, with its paper tag paying
tribute to the Scottish Poetry Library's
hashtag on Twitter: @ByLeavesWeLive

The first gift's protected place in the Scottish Poetry Library, where visitors from as far afield as Germany and Australia have come to marvel at it, alerted by the story online.

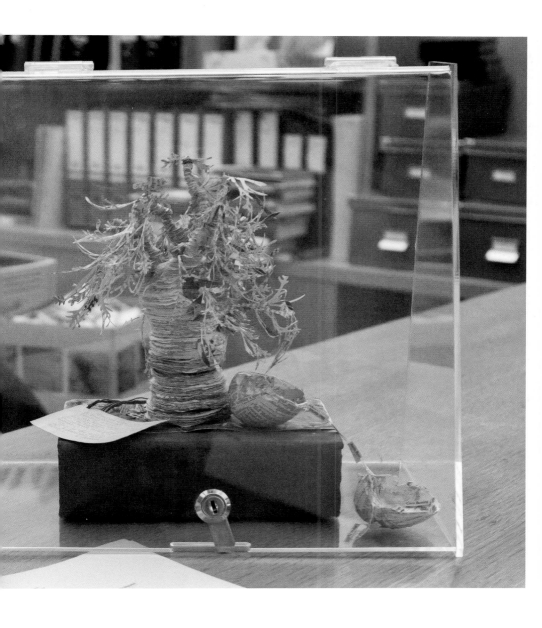

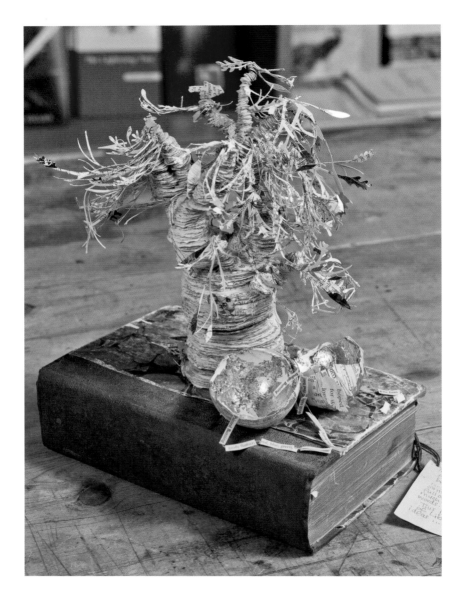

The artist has generously provided a guide to
making a 'poetree' – see pp.93–96.

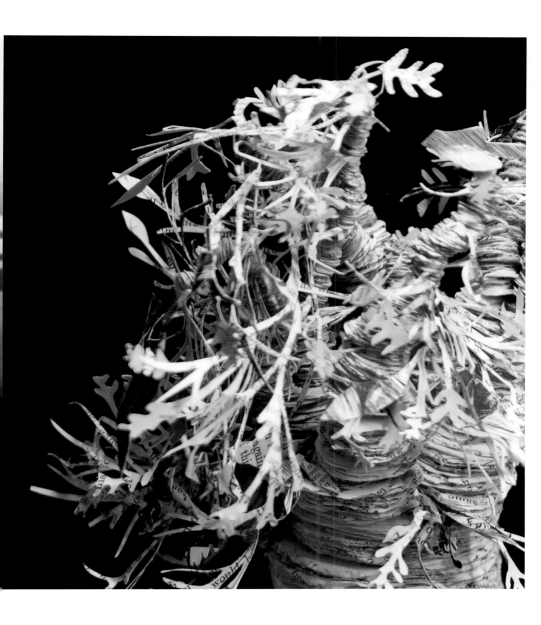

2 It turned out that this was not a one-off occasion, when the second book sculpture appeared in late June 2011, at the National Library of Scotland's austere main building on George IV Bridge.

There was a direct reference back to the Scottish Poetry Library: the Crichton's Close building is the scene of a Russian poet's murder in *Exit Music*, the novel that marked the retirement of Ian Rankin's famous Detective Inspector John Rebus. The second sculpture was crafted from a copy of *Exit Music*, with its coffin and gramophone a visual pun on the title.

The threat to public libraries in the UK has been highlighted by various campaigning organisations, and interventions by well-known authors, such as Philip Pullman's widely reported speech to the Library Campaign's conference in October 2011: 'A book symbolises the whole intellectual history of mankind; it's the greatest weapon ever devised in the war against stupidity.

Beware of anyone who tries to make books harder to get at.' The sculptor who delivered this second work is well aware of the background of cuts and closures, as the tag suggests: '... & against their exit'.

www.nls.uk

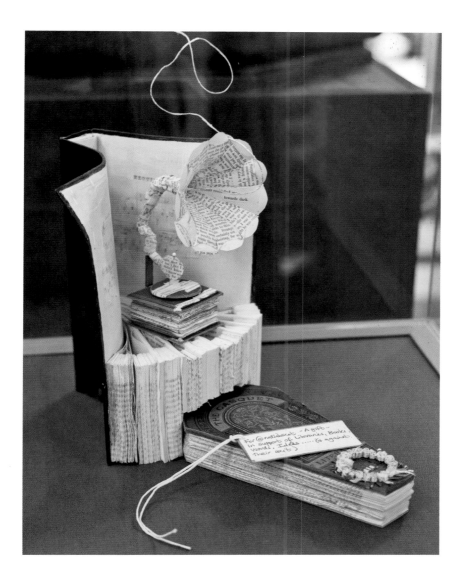

Is the coffin sliding between the fanned-out pages of the book from which the music rises, as in a cremation service, or does it resist disappearance as the music plays on?

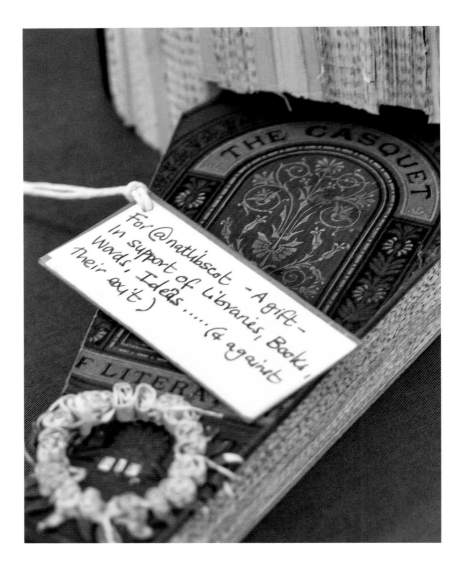

The coffin – or casket – is shaped from a late-nineteenth-century edition of *The Casquet of Literature*, 'a selection of prose and poetry from the works of the most admired authors', which suggests both the sculptor's regard for Rankin's work, and the sense of the mortal 'remains' of authors sealed in the books.

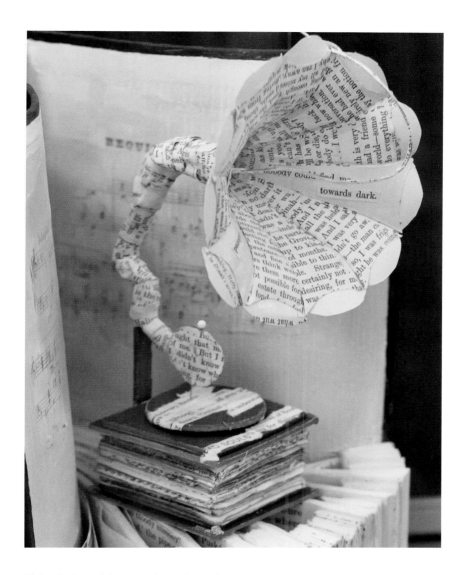

Within the horn of the gramophone, the words
'towards dark' suggest the movement of the
coffin below.

3 Within days, staff at the Filmhouse were thrilled to discover that libraries were not the only object of the sculptor's generosity. Once a boarded-up church, the Filmhouse came into being as an independent cultural cinema in 1979, and opened its second screen and social amenities in 1985.

The sculptor was paying tribute to 'all things magic' – no doubt including the 'magic lantern', invented in the seventeenth century and a distant ancestor of the modern cinema, since it could project an image. In this complex and animated sculpture, the images have come alive, men and horses tearing out of a cinema screen towards the audience, the screen itself formed from a book – a reminder of how many films have been adapted from books. The spectators are sitting on a tier of books, and one of them – you have to look very closely – is holding a can of Deuchars, known to be Ian Rankin's beer of choice and the Filmhouse is his local cinema. Thus the connections of one sculpture with another are subtly made.

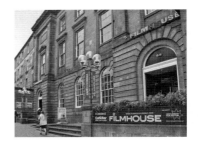

www.filmhousecinema.com

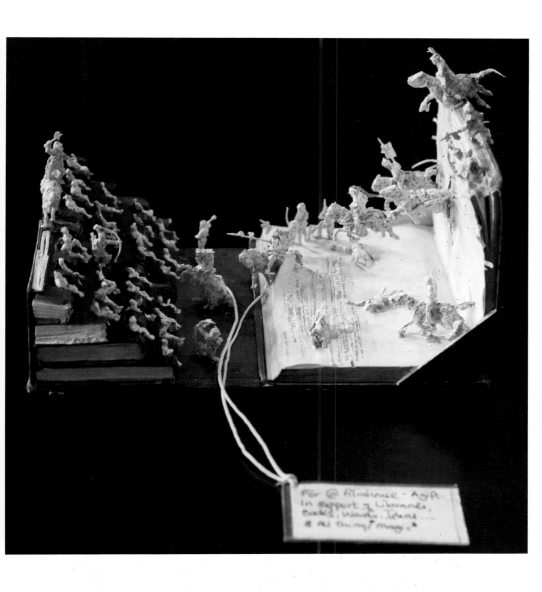

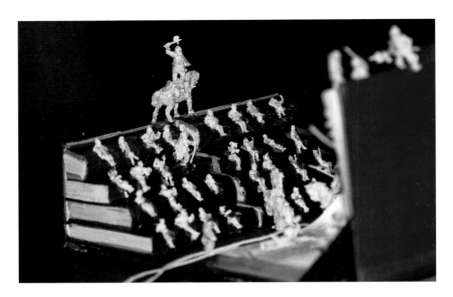

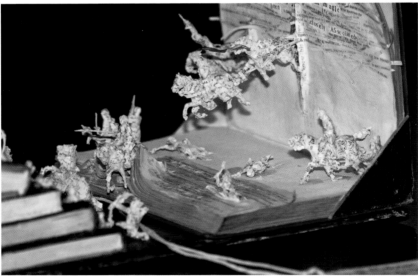

The text ribbons use quotes from a 1994
interview with the director Francis Ford
Coppola: 'I think cinema, movies, and magic
have always been closely associated.
Because the very earliest people who
made film were magicians.'

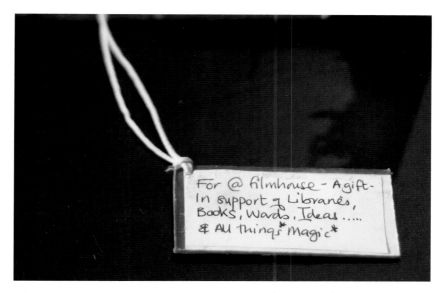

The seated figure on the far left is not only
holding a beer can but also has the features
of Ian Rankin.

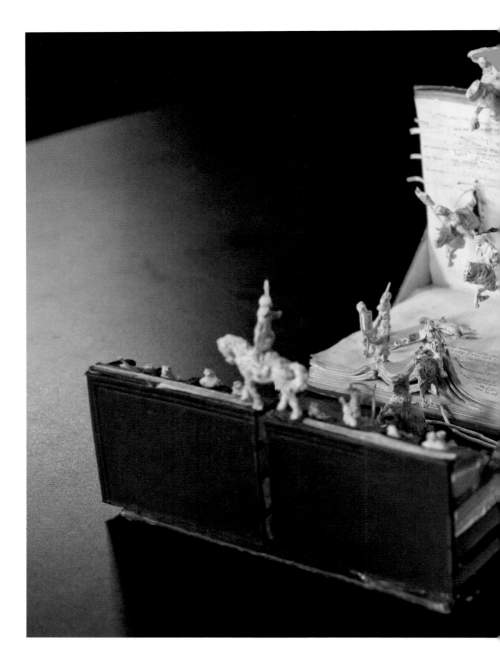

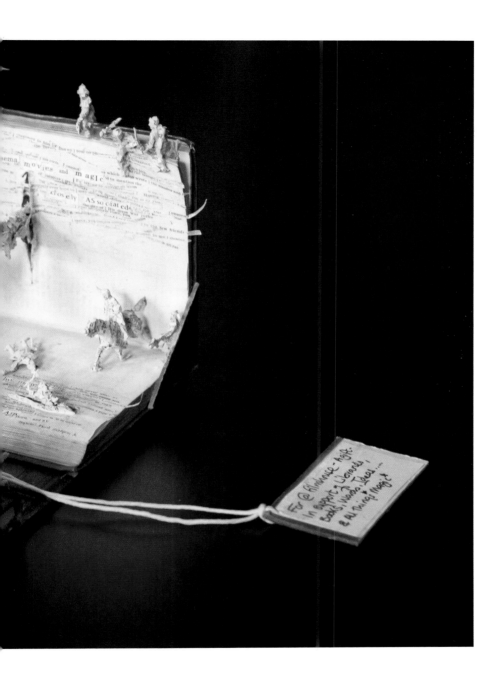

4 — *The Scotsman* on 11 July broke news of the discovery in the Scottish Storytelling Centre of a fourth sculpture. It may have been there for some days, the staff admitted, so stealthy had the sculptor been. The Storytelling Centre sits on the Royal Mile next door to John Knox's House, and since 2006 has existed in its present incarnation.

It is home to the art of storytelling with its æons of oral tradition, and it has been instrumental through the Storytelling Network in reviving and nurturing the art in Scotland and connecting Scottish tellers with their counterparts across the world.

There are some beasts that feature in stories no matter what country they come from, and surely the dragon is one of them. 'Once upon a time,' the tag reads, 'there was a book and in the book was a nest and in the nest was an egg and in the egg was a dragon and in the dragon was a story…' Which came first, the dragon or the egg? A nice variation on an old question.

The beautiful curlicues of the nesting materials render the dragon more friendly than ferocious, but perhaps the sculptor also had in mind a late poem by Edwin Morgan, who looked back to his translation of *Beowulf* in 'The Last Dragon'. There the dragon is death, which despite all

the hero's valour carries him off, and which the artist resists through art. The theme of death connects with Rankin, as does the evocation of story, as surprising in its twists and turns as the dragon coiling out of an egg.

This appearance of a fourth sculpture, and at the beginning of the festival season in Edinburgh, fuelled speculation and excitement: perhaps there were more to come? There was a month's wait, and then...

www.scottishstorytellingcentre.co.uk

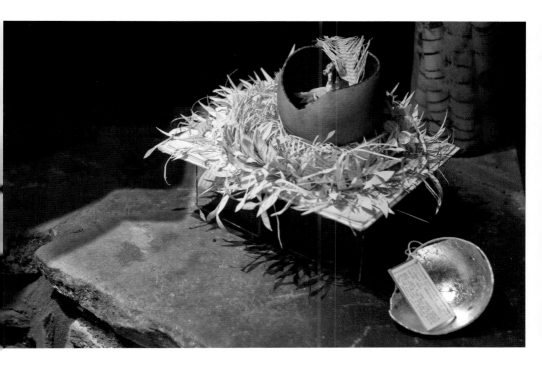

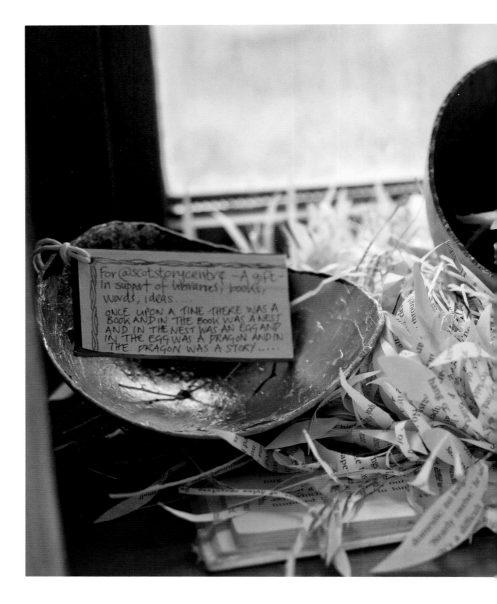

The egg takes us back to the first book
sculpture: there it held poetry and song;
here it holds the dragon, subject of poems
and songs and tales.

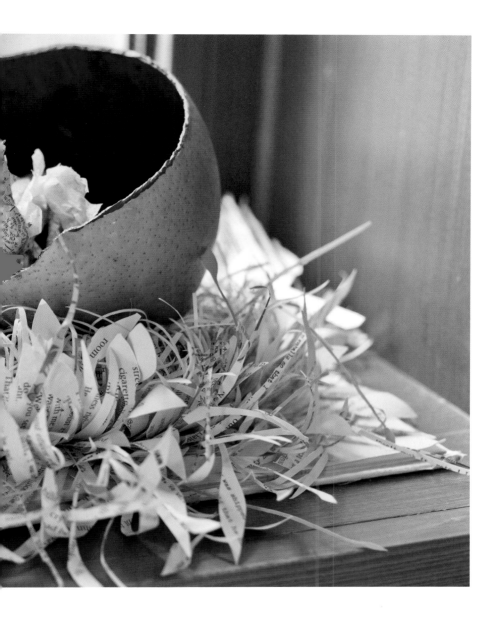

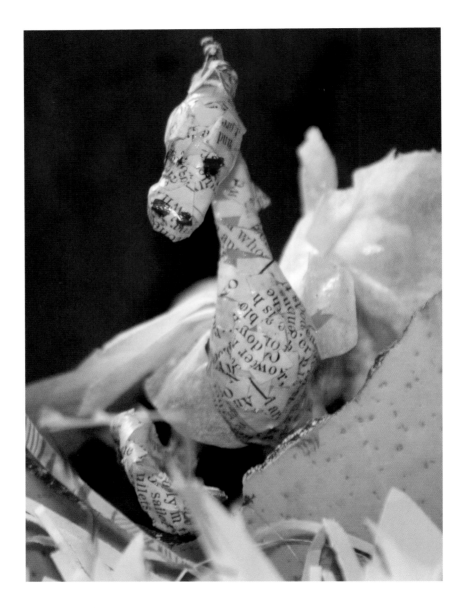

The book used for this sculpture is Ian
Rankin's first Rebus novel, *Knots and
Crosses* (1987): who can say for sure
whether a knot will be a life-saver or a
life-destroyer?

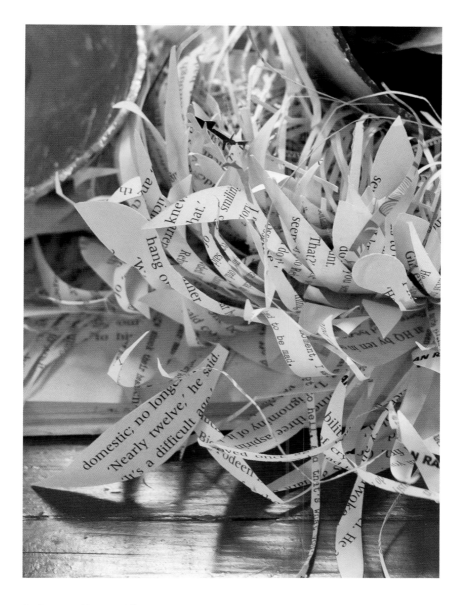

Rankin wrote *Knots and Crosses* as an up-
dated version of Robert Louis Stevenson's
Strange Case of Dr Jekyll and Mr Hyde: like
a dragon, a good story can always be re-
imagined, reborn.

5–6

... two appeared at once! Shrieks were heard even above the sound of the traffic in Charlotte Square, rising up from the Edinburgh International Book Festival's pitched tents – their annual appearance since 1985 signalling two weeks of excitement for writers and readers at the world's largest book festival.

Chris Scott was summoned to record the discoveries, on a signing table in one of the bookshops and secreted in the Edinburgh UNESCO City of Literature stand at the entrance to the Festival.

He photographed the EIBF's sculpture in the yurt, where authors gather to prepare for their talks and readings, where old friends meet and new acquaintances are made, where the famous and the first-timers retreat to eat, drink, and prepare the 'face to meet the faces they will meet', as Eliot said about less convivial circumstances. This is a very delicate construction: 'this cup is awarded to @edbookfest', proclaims the line cut out and pasted below the book on which a teacup is poised on its stand. On its tea-surface, the 'milk'-swirl reads: 'Nothing beats a nice cup of tea (or coffee) and a really great BOOK' – although the nearby cup-cake has a caption 'except maybe a cake as well'.

This lovely word play expanded with the sculpture given to the Edinburgh UNESCO City of Literature Trust, which

since 2004 has worked to promote and enhance Edinburgh's role as a world City of Literature, drawing on its heritage and encouraging new developments. Here is a figure literally 'lost in a book', a concept of deep pleasure to the book-festival-going and reading public. Yet, as the tag underlines, being lost is also a cause of bewilderment and frustration: the open book is not open to everyone – and it has been part of EUCL's work, through its citywide reading campaigns, to provide a way into books.

Robert Owen (1771–1858) was a great Welsh social reformer, with his model factories and schools in the settlement of New Lanark on the banks of the Clyde. In quoting Owen – 'No infant has the power of deciding … by what circumstances [they] shall be surrounded' – the sculptor points both to the plight of the individual who has no control over their surroundings – and sits powerless in that impenetrable forest – and to the responsibility for creating those surroundings to different effect, as Owen tried to do. One way out of such powerlessness is through education, formal or informal, in which libraries have played such a vital role. How many writers have spoken of their education through what they came across on the shelves of public libraries! So this sculpture speaks of the concept of nurturing reading, its availability and pleasures: at one level, of the escape from circumstances beyond our control that being 'lost in a book' provides.

But is this also a guilty pleasure? The question arises inevitably as we see that the book from which this sculpture is crafted is the Scottish classic, *The Private Memoirs and Confessions of a Justified Sinner* by James Hogg, first published anonymously in 1824. Ian Rankin has written a film script of this deeply Calvinist whodunit, which has been influential for a whole range of Scottish writers.

www.edbookfest.co.uk www.cityofliterature.com

Admiring the book sculptures on a sunny
afternoon in Charlotte Square, where the
Edinburgh International Book Festival sets
up its tents for a fortnight every August.
Photographs of the latest sculptures went
online and round the world that afternoon.

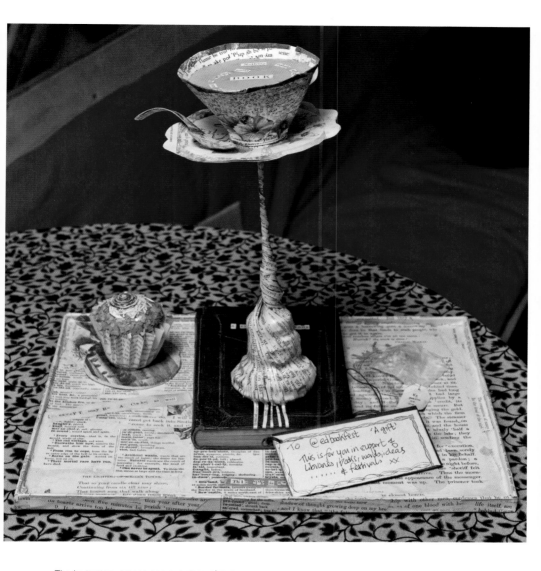

The levitating vintage tea-cup rises above its book as though conjured from its pages. The sculpture suggests both the pleasures of reading alone, with tea to hand, and the sociable atmosphere of the Book Festival, where morning readings are accompanied by coffee and pastries.

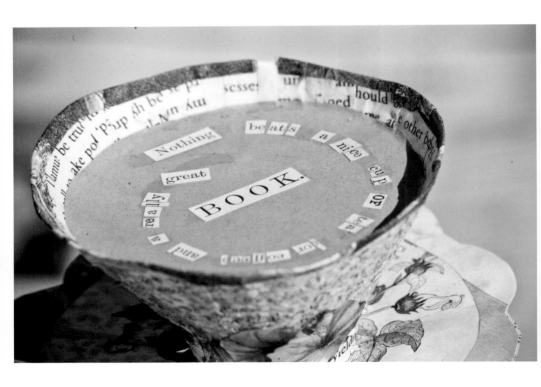

'This cup is awarded to @edbookfest' – the
hashtag on Twitter of the Book Festival.

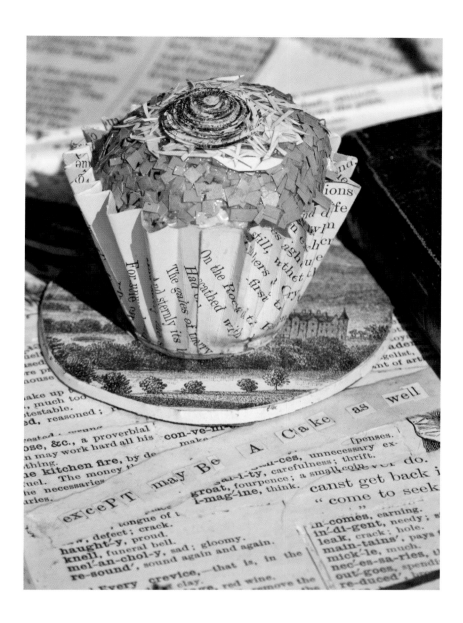

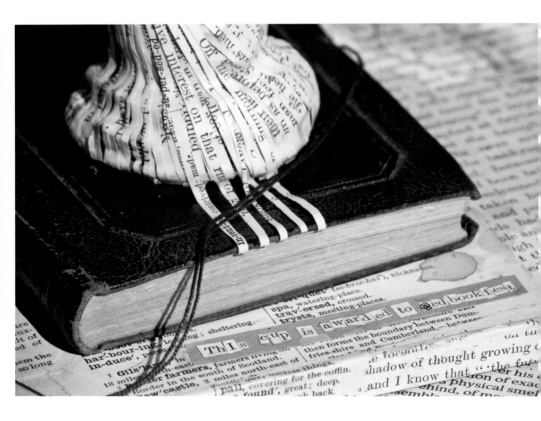

Even the tea-tray is intriguing: it looks like an historical narrative, with a glossary provided. It seems to be a tale of finance and failure… and includes the word *mickle*, glossed as 'great', which in Scots means the opposite, 'a small amount'.

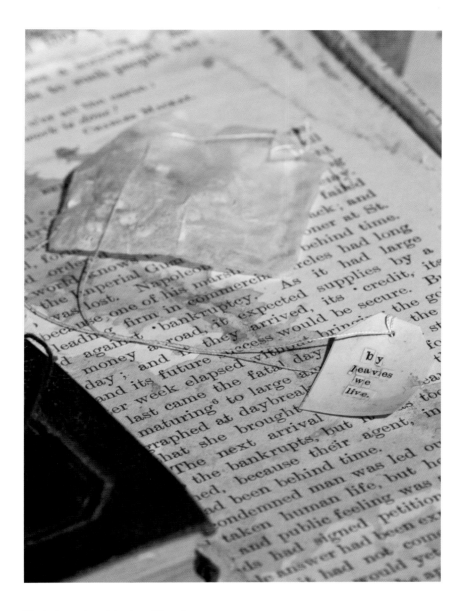

The texts are tea-stained, and there is a
tea-bag full of letters with its tiny tag 'by
leaves we live'. Of course tea leaves, too,
may be 'read'.

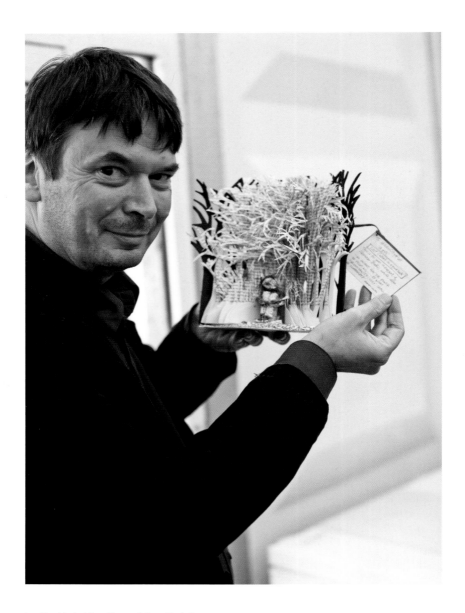

Ian Rankin holding the sculpture that draws
attention to Edinburgh's designation as the
first UNESCO City of Literature. The small
figure lost in its pages may not – as the tag
says – have control over circumstances, but
nevertheless has this retreat from them.

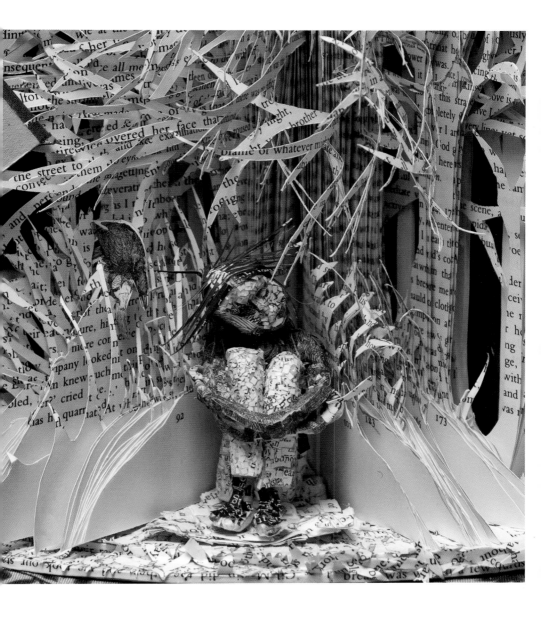

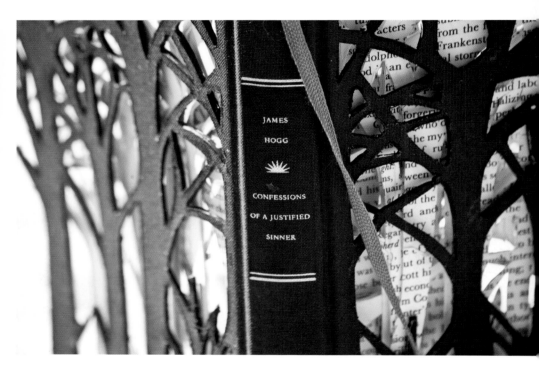

The sculpture is made from James Hogg's *Private Memoirs and Confessions of a Justified Sinner*. Rankin wrote an introduction to the Edinburgh publisher Canongate's reprint of the text in 2008, imagining pitching the story to a film company: 'Thriller – popular genre. Serial killer – good and scary. Political dimension – adds extra demographic. Psychological element – makes it more grown-up. Religious spin – plausible.' He calls it a masterpiece of world literature.

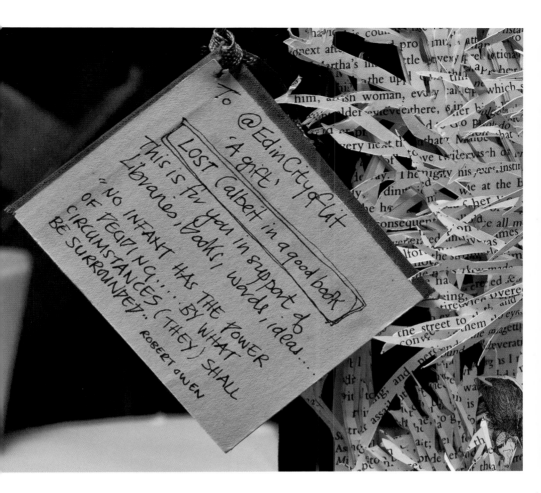

Robert Owen, social reformer and educator, would have approved of the 1989 Convention on the Rights of the Child, which is one of UNESCO's governing documents: Articles 28 and 29 stipulate that primary education should be 'compulsory and available free to all', and that it should allow children to reach their fullest potential.

7 The Edinburgh International Book Festival had packed up all its tents, and Charlotte Square was emptied of crowds and books. Edinburgh's great annual International Festival of music, theatre and dance still had a few days to run, and there were crowds in the Old Town as the Festival Fringe continued with its mad and merry dance, when someone deep in the Central Library stumbled upon a gift. Who knows how many days it had been there?

This fine public library, with its Edinburgh Room and large reference and borrowing collections, sits opposite the National Library of Scotland and was opened to the public in 1890 – Andrew Carnegie had laid the foundation stone in 1887. The sculptor knows that the upkeep of such historic libraries is considerable: 'libraries are EXPENSIVE' reads the tag, but the 'second 'E' is crossed out and replaced with an 'A' – because what libraries do is expand our minds, broaden our horizons.

That play with one vowel is very much in the spirit of Edwin Morgan, which presides over this gift. The cover of the book, with its Celtic knotwork, is a bright, Saltire blue – the colour of the Scottish flag appropriate for the poet who loved (not uncritically)

his nation. The magnifying glass that circles his words suggests the forensic gaze of the poet, but it is also a burning glass, scorching a hole right through the cover of the book.

The words here come from the concluding poem of Morgan's *Collected Poems*, 'Seven Decades', in which he looked back over his life, and of course at 70 could not predict that he would live another 20 years. With his typical, lifelong curiosity, Morgan asked that when the last veil was drawn aside, he wanted 'it bright / I want to catch whatever is there / in full sight'. It is the opposite of Rankin, whose work thrives on mystery, on things not brought to light – he is a huge fan of Morgan's poetry. Being a verse about the 'last exit', though, links it neatly with the sculpture given to the National Library across the road.

This seems perhaps a modest sculpture after the intricacies of the others, but its comparative sturdiness suits its surroundings. What a world there is in a book, if one reads by a bright light: so much in a small compass, so much light shed on what is obscure, fantastic, troubling, amazing.

www.edinburgh.gov.uk/directory_record/5079/central_library

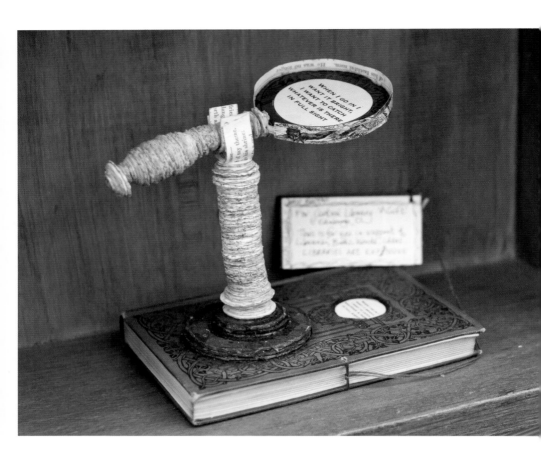

It may be fanciful to suggest that the firm
black outline of the lens recalls Edwin
Morgan's familiar, black-rimmed spectacles.

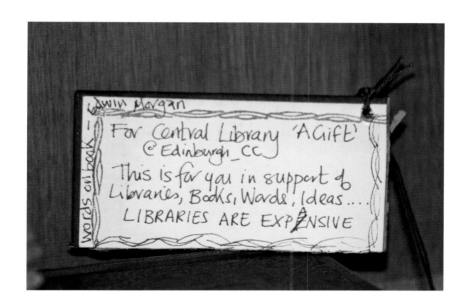

As in the sculpture for the National Library of Scotland, the artist returns to the idea of the threatened public library system, and turns the negative idea of cost into the positive idea of open access: for all people, to all books.

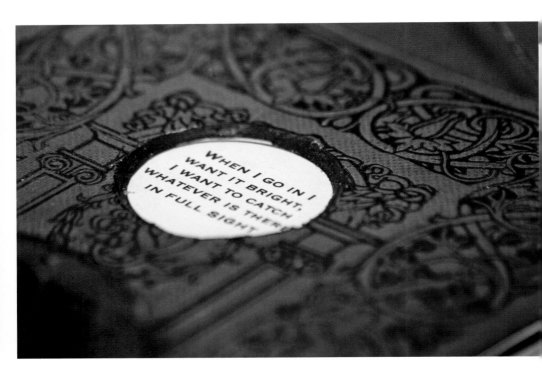

WHEN I GO IN I
WANT IT BRIGHT,
I WANT TO CATCH
WHATEVER IS THERE
IN FULL SIGHT

All the authors connected with the book sculptures have lived in Edinburgh, except for Edwin Morgan, who was a Glasgow man through and through. Morgan was appointed Scots Makar – or National Poet – in 2004, and held the position until his death in 2010. The Edwin Morgan Archive, at the Scottish Poetry Library, is a comprehensive collection of his printed work.

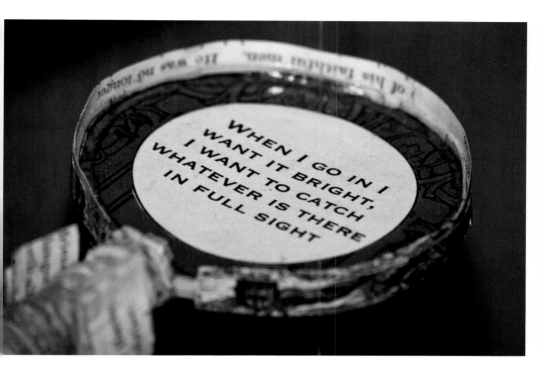

WHEN I GO IN I
WANT IT BRIGHT,
I WANT TO CATCH
WHATEVER IS THERE
IN FULL SIGHT

Welcoming librarians to a conference in
Glasgow, Morgan wrote: 'unlock /
Your word-hoards, take heart and take stock /
Of everything a library can do / To let
the future shimmer and show through.'

8 The story kept surfacing on the internet. Journalists came, so did television crews, visitors sought out the sculptures, people were still discovering and exclaiming over them online. In late September, Edinburgh's *Evening News* claimed to have discovered the sculptor.

But the Twitter world and the web fans were not really interested: the general view was that they didn't want to know, that the sculptor's anonymity was to be respected.

He or she had not asked for fame let alone a reward, but had used the sculptures to highlight and pay homage to 'libraries, books, words, ideas…', things that can be freely enjoyed in Edinburgh where they are housed for the nation and the world. That they – like the news of the sculptures – can also be accessed and shared through social media, that this could spark conversation and even encourage the artist, has been one of the most heartening aspects of the whole series of discoveries.

We thought it had perhaps come to a quiet conclusion, but the sculptor had other ideas – plenty of them, as it turned out. The staff at the Scottish Poetry Library didn't notice anyone in particular leaving a comment in the visitors' book, but there it was on 23 November, directing them to the shelf where the antholog-ies of women's poetry are stacked for lending.

An excited dash to the shelf showed the gift of 'Gifts', based on Norman MacCaig's poem of that name.

GIFTS Norman MacCaig

You read the old Irish poet and complain
I do not offer you impossible things –
Gloves of bee's fur, cap of the wren's wings,
Goblets so clear light falls on them like a stain.
I make you the harder offer of all I can,
The good and ill that make of me this man.

I need no fancy to mark you as beautiful,
If you are beautiful. All I know is what
Darkens and brightens the sad waste of my thought
Is what makes me your wild, truth-telling fool
Who will not spoil your power by adding one
Vainglorious image to all we've said and done.

Flowers need no fantasy, stones need no dream:
And you are flower and stone. And I compel
Myself to be no more than possible,
Offering nothing that might one day seem
A measure of your failure to be true
To the greedy vanity that disfigures you.

A cloak of the finest silk in Scotland – what
Has that to do with troubled nights and days
Of sorry happiness? I had no praise
Even of your kindness, that was not bought
At such a price this bankrupt self is all
I have to give. And is that possible?

This deeply romantic poem, alluded to by the tag, speaks of things that are impossible and of things ending, too; of the vanity of creation; of the mix of light and dark, hope and hopelessness that all in love are prey to – and we can be in love with 'books, words and ideas' as much as with people.

Thus the sculptor made the impossible requests possible: the feather cap exquisitely figured in paper with its speckled print; the bees' fur gloves with a bee resting on them. The sharp eyes of the Assistant Librarian and her search experience led to the revelation that the book used in making the cap – or at least in lining it – is likely to be Jules Verne's *In Search of the Castaways*. This had significance because of the tag: 10/10.

It signalled both the end and not the end of the sculptures' story. The sculptor's letter (see opposite) said it was 'important that a story is not too long', did 'not become tedious', that it should end where it began, in a place 'where they are well used to "anon"'.

She ('some had even thought it was a "he"!... As if!') thanked the Twitter community, Chris Scott for giving the story 'a place, a shape and some great pictures', and Ian Rankin @Beathhigh, 'whose books and reputation have been shamelessly utilised in the making of a mystery'.

That was number 8 by all account: there must be two castaways still to be found!

It's important that a story is not too longdoes not become tedious 'You need to know when to end a story,' she thought.

Often a good story ends where it begins. This would mean a return to the Poetry Library. The very place where she had left the first of the ten.

Back to those who had loved that little tree, and so encouraged her to try againand again.

Some had wondered who it was, leaving these small strange objects. Some even thought it was a 'he'! As if!

Others looked among Book Artists, rather good ones actually.......

But they would never find her there. For though she does make things, this was the first time she had dissected books and had used them simply because they seemed fitting.....

Most however chose not to know..... which was the point really.

The gift, the place to sit, to look, to wonder, to dream..... of the impossible maybe......

A tiny gesture in support of the special places.....

So, here, she will end **this** story, in a special place ... A Poetry Library where they are well used to 'anon.'

But before exiting ...a few mentions. There could be more, because we have all colluded to make this work....... Just a few though.

- the twitter community who in some strange way gave rise to the idea in the first place

-@chrisdonia who gave the story a place, a shape and some great pictures

- and not least @Beathhigh whose books and reputation have been shamelessly utilised in the making of a mystery

...... But hold on. Someone's left behind a pair of gloves and a cap............?

Cheers Edinburgh It's been fun!
X

The torn leaf was left alongside the final gift
at the Scottish Poetry Library, explaining
some things but leaving the rest mysterious.

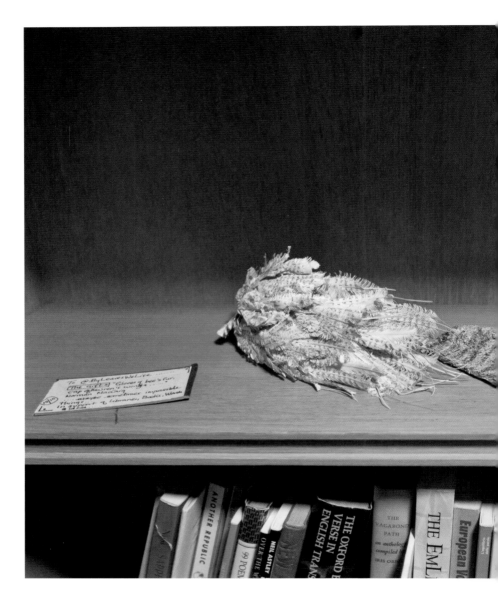

The Scottish Poetry Library houses books from all over the world: it seemed appropriate that this gift – noticed worldwide and made by a woman – should have been left between the shelves of international and women's anthologies.

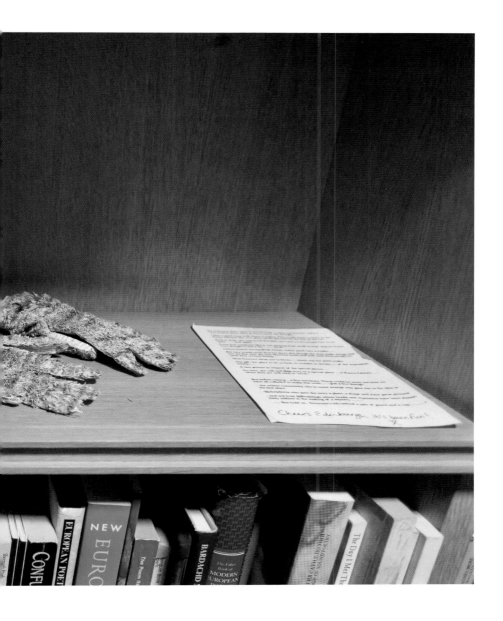

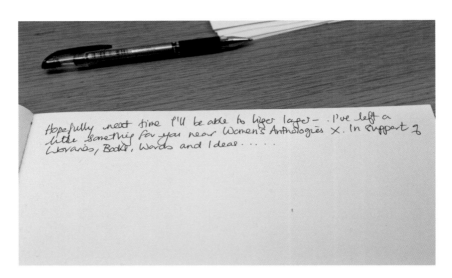

Hopefully next time I'll be able to linger longer —. I've left a little something for you near Women's Anthologies X. In support of Libraries, Books, Words and Ideas......

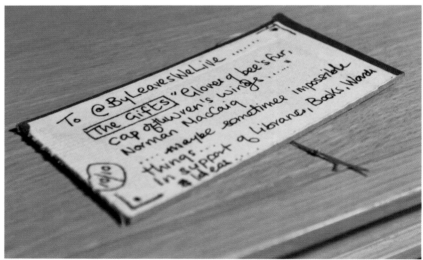

To @ByLeavesWeLive
"The Gifts" "Cloves of bee's fur,
cap of the wren's wings
Norman MacCaig
....... maybe sometimes impossible
things In support of Libraries, Books, Words
In support of ideas

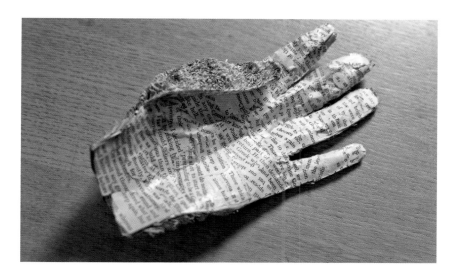

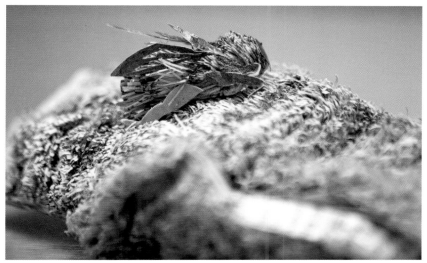

'Gloves of bee's fur' – it took a little while
to see that a bee had alighted on one finger.
But the SPL staff find it hard to believe
that they missed seeing someone leave the
inscription in the visitors' book, right opposite
the reception desk!

9

This one had gone walkabout. A member of staff had spotted the book sculpture hiding underneath a stag in the National Museum of Scotland in Chambers Street, up the road from the National and Central libraries.

Chris Scott, posting photos on his blog with all speed, explained:

> It soon made its way up the chain of command, until it came to rest in the Director's office for safety. Meanwhile, the museum staff were abuzz with the imminent arrival of their millionth visitor since re-opening (which was a surprise, as that wasn't really expected until about August 2012), so they didn't have time to tell the world about it until that excitement had died down.

The tag referred back to the sculptures found in the summer in Charlotte Square: 'Your friends at @edbookfest suggested you might like this. ... In support of libraries, books, words, ideas and those places that house our treasures...'. Amongst those treasures now is this paper Tyrannosaurus Rex, bursting out of the shredded leaves of a book. Not just any book, of course: Edinburgh-born Arthur Conan Doyle's *The Lost World* (1912), a tale of dinosaurs and exploration considered to be the inspiration for the film *Jurassic Park*.

Tiny men with weapons and pith helmets lurk in the foliage, and the dinosaur has a smear of blood on

his jaws. Perhaps the dinosaur directs our attention not only to the Filmhouse, but also back down the road to the National Library, where the John Murray Archive holds letters from Charles Darwin about his controversial book, *On the Origin of Species...*

Surely the missing sculpture had to be found where Edinburgh commemorates the Grand Old – or not so old – Men of Scottish literature: Robert Burns, Sir Walter Scott and Robert Louis Stevenson?

www.nms.ac.uk

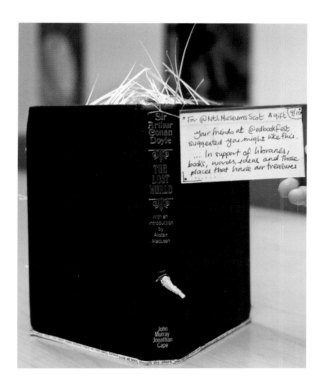

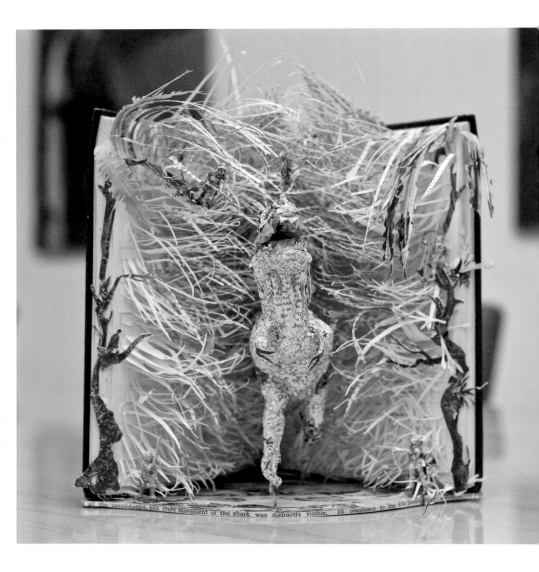

The choice of *The Lost World* links this sculpture to Edinburgh UNESCO City of Literature, as the book featured in its 2009 city-wide reading campaign. Its author, Arthur Conan Doyle, was also the creator of the world's most famous fictional detective, Sherlock Holmes.

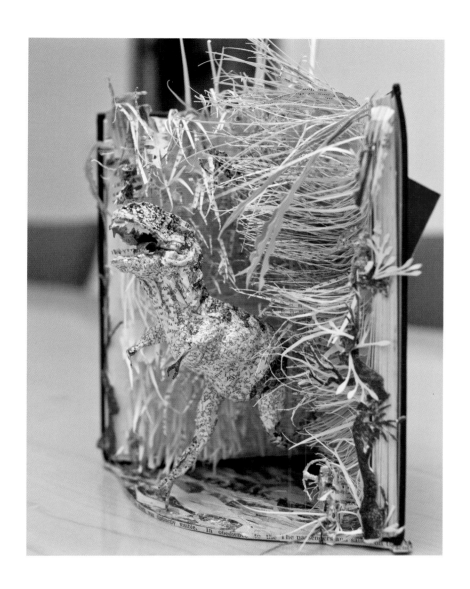

The tiny fighting figures are almost
indistinguishable from the foliage.

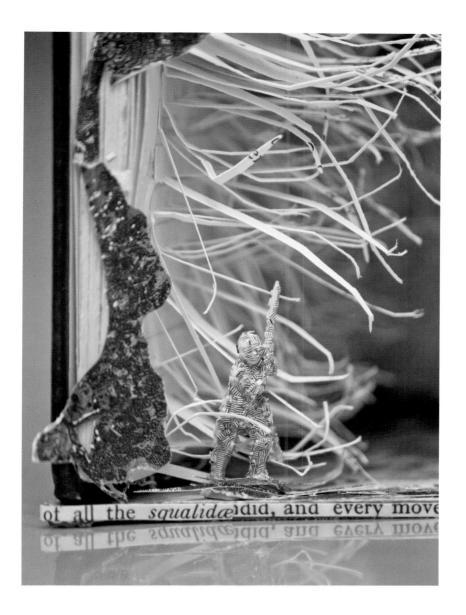

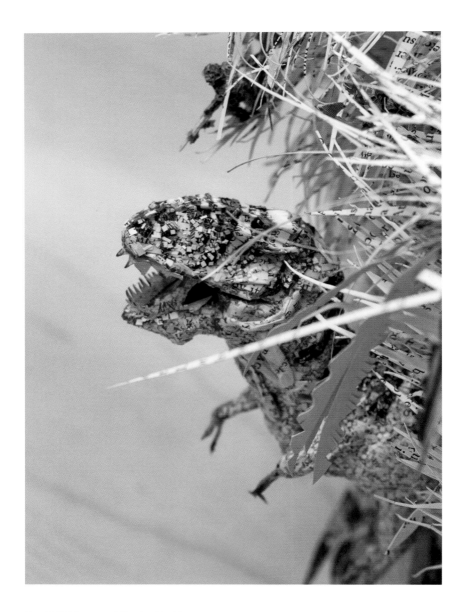

The 1998 Museum of Scotland building is
faced with golden Moray sandstone, which
one of its architects has called 'the oldest
exhibit in the building' – even older than the
Jurassic sediments on Skye, for example,
where dinosaurs probably roamed.

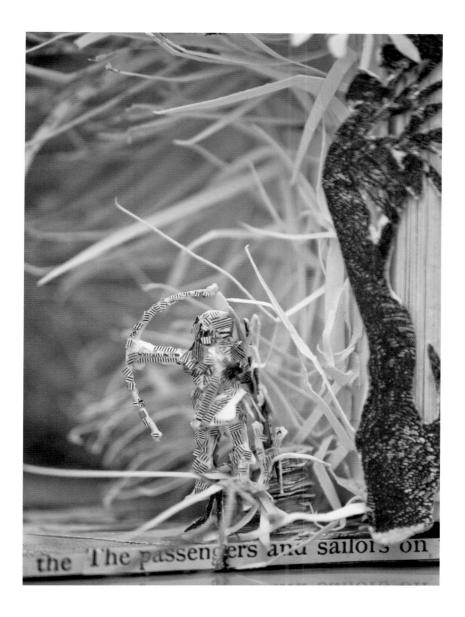

10

And so it proved. The eighth sculpture may have been there several months, lurking unnoticed among the wealth of exhibits in the Writers' Museum, housed in a 1622 building that was renovated as a museum in 1907, in Lady Stair's Close near the top of the Royal Mile. Outside the Museum is a paved courtyard known as the Makars' Court, where stones have been placed to commemorate a variety of Scottish writers, from the fourteenth century to the twentieth.

Thus Ian Rankin's phrase 'The stories are in the stones' is particularly apt to this corner of Edinburgh, although the whole of the Old Town speaks through its buildings, wynds and closes.

The boards that form two sides of this sculpture are the covers of Rankin's second Rebus mystery, *Hide and Seek* (1991), which continued to draw on his fascination with Stevenson's *Strange Case of Dr Jekyll and Mr Hyde*. They open out to reveal an intricate frontage of Old Town tenement buildings and half-concealed entrances, lit on one side by a streetlamp and the other by a suspended paper moon. The street-lamp evokes one of Stevenson's poems from *A Child's Garden of Verses*: 'But

I, when I am stronger and can choose what I'm to do, / O Leerie, I'll go round at night and light the lamps with you!'

On the steps, over the modern text, a phrase has been pasted: 'commingled out of good and evil'. Misha Hoekstra pointed out that this is taken from *Jekyll and Hyde*:

> 'I have observed that when I wore the semblance of Edward Hyde, none could come near me at first without a visible misgiving of the flesh. This, as I take it, was because all human beings, as we meet them, are commingled out of good and evil: and Edward Hyde, alone in the ranks of mankind, was pure evil.'

This is a marvellously detailed 'set', with its Victorian woman being attacked in the long shadow falling from the lamp, the pentagram scrawled on a wall in red, and birds on a wire – the old crows of Scottish ballads – heads cocked at activities mostly concealed behind the tenement windows. It is the storied Old Town and the riven Scottish psyche, delicacy and deadliness combined.

www.edinburghmuseums.org.uk/Venues/The-Writers--Museum

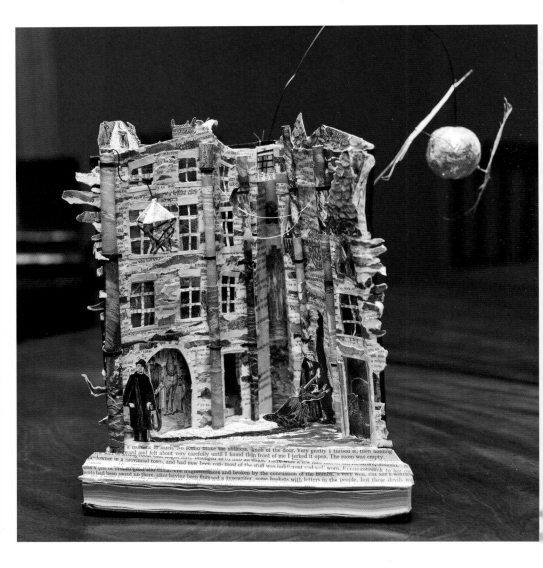

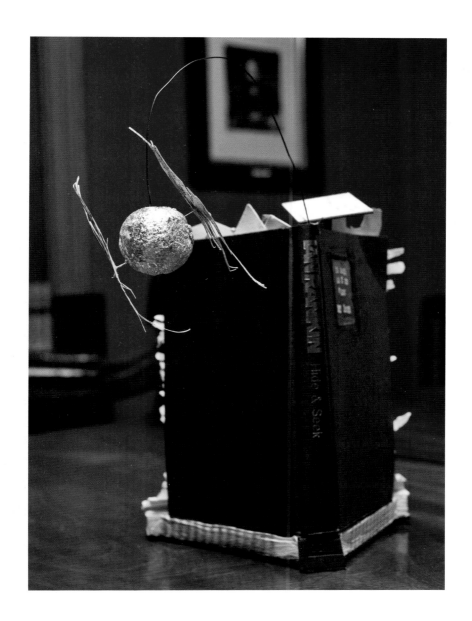

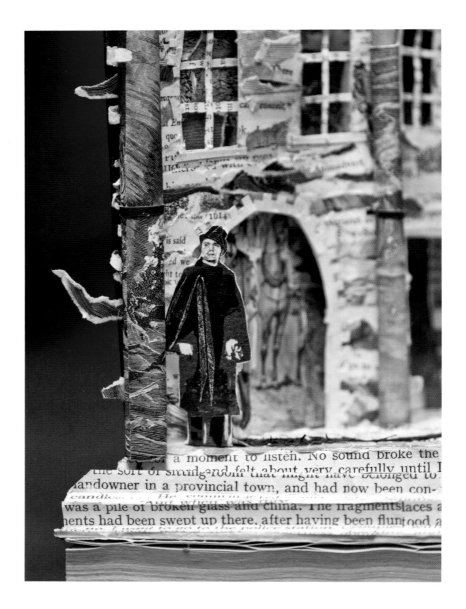

The figure in top hat, cloak and cane on the left-hand side of the scene looks like a cut-out from the 1931 film *Dr Jekyll and Mr Hyde*, starring Fredric March. Again this takes us back to the Filmhouse and the figure of Rankin amongst the spectators.

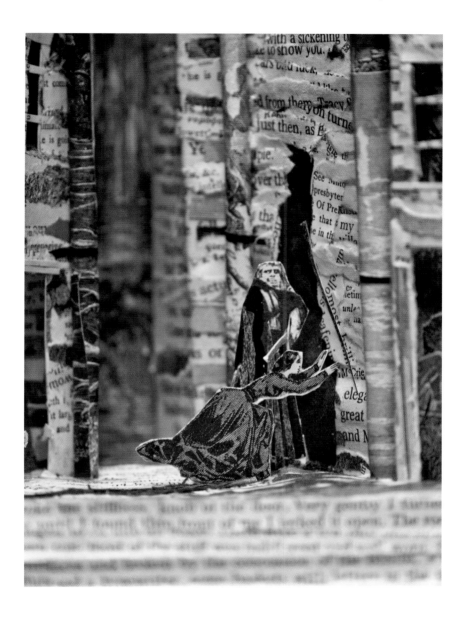

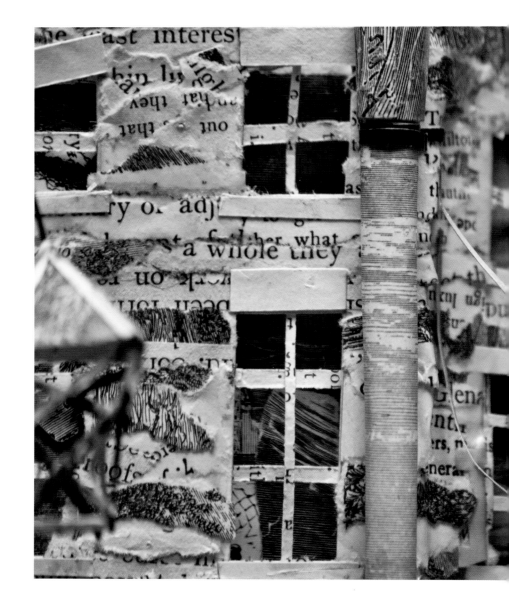

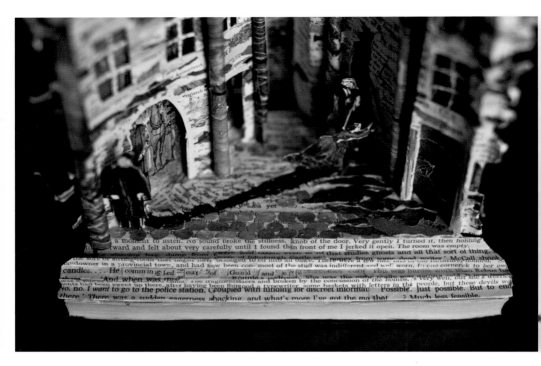

Edinburgh-born Robert Louis Stevenson's novella was a publishing sensation in 1886, 'born of a nightmare and produced in white-hot haste'. 'Jekyll and Hyde' has entered the language as a shorthand description of split personalities, but Stevenson – and Rankin – portray more than simple dualities in their fiction.

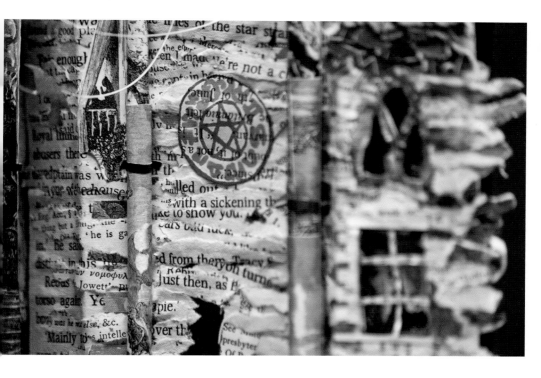

Ian Rankin's *Hide and Seek* opens with a
dead junkie in an Edinburgh squat, where
a five-pointed star is daubed on the wall.

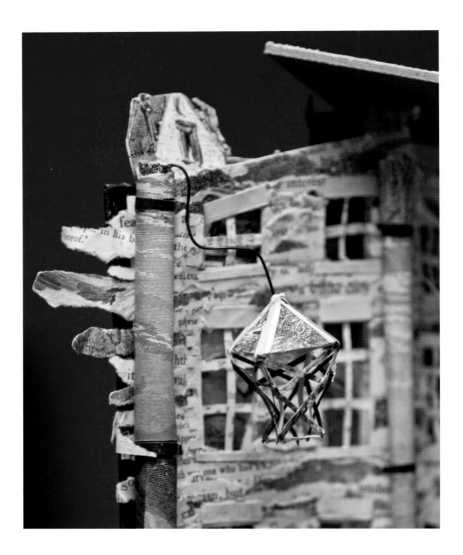

In contrast, Stevenson's poem 'The Lamplighter'
evokes a very benign figure, seen from the
window where a sick boy – as the poet was
– kept watch for him: 'For we are very lucky,
with a lamp before the door, / And Leerie
stops to light it as he lights so many more;
/And oh! before you hurry by with ladder and
with light; /O Leerie, see a little child and nod
to him to-night!'

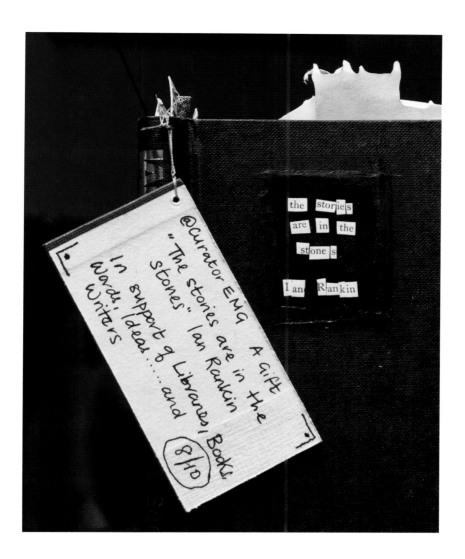

THE STORY CONTINUES On 25 November 2011, Ian Rankin advised the Edinburgh Bookshop in Bruntsfield Place that he was expecting a parcel, and could they let him know when it had been delivered... A text brought Rankin and Chris Scott hurrying to the shop, and there was number 11 out of 10.

A bonus sculpture. Two skeletons sit on a coffin-lid, and perched beside them on an old book is a tiny turntable. The record sleeve bears the legend 'The Impossible Dead / Ian Rankin / some secrets never die' – and indeed the skeletons are clearly having a sociable time, drinking and smoking and listening to music. The RIP date on the coffin lid, 13/10/11, is the date *The Impossible Dead* – Rankin's Malcolm Fox mystery which moves out of Edinburgh to Fife – was published. This sculpture is now safely tucked up in Rankin's home.

There's more to be said, more to be noticed, no doubt. Some of these institutions will have their sculptures on show when you visit, some will not be able to make them permanently available because of the constraints of space and other exhibition plans. But if the book sculpture trail takes you to all these places, that in itself will have fulfilled one of the sculptor's aims: to support libraries, books, words, the places where magic happens. Every one of the locations has been chosen with care, treasure-houses whose guardians have been rewarded in kind.

We wish you as much delight in seeing them as she obviously had in making them.

www.edinburghbookshop.com

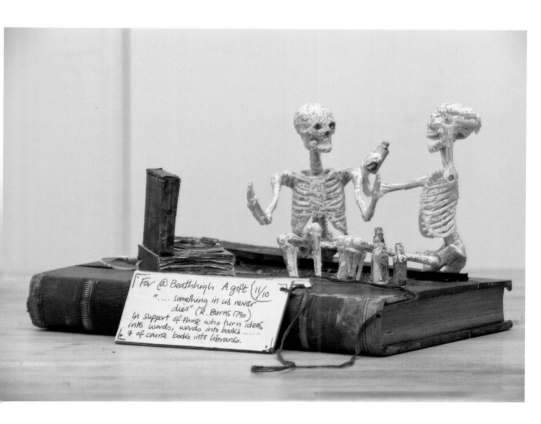

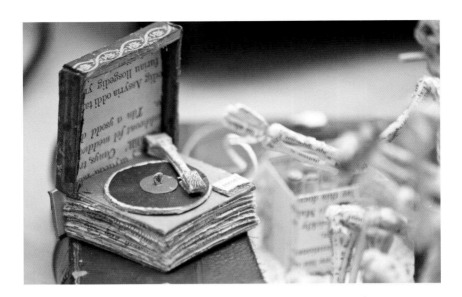

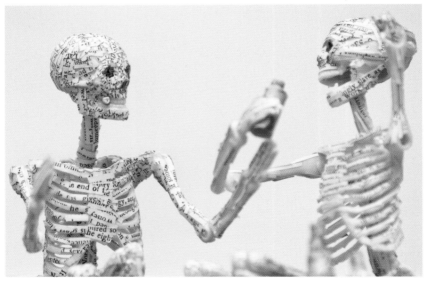

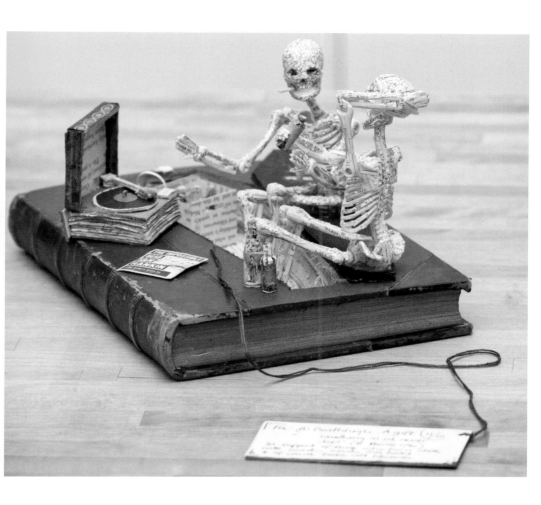

The tag reads: 'For @Beathhigh A gift "…
something in us never dies" (R. Burns 1790)
In support of those who turn ideas into words,
words into books… & of course books into
libraries.' The quotation from Scotland's
most famous poet, Robert Burns, comes from
'Sketch – New Year's Day [1790] To Mrs
Dunlop', urging her not to mourn for the year
that's passed but to listen to the voice of
Nature, which suggests that life is continually
renewed.

So many people had followed this story online and in print that we wanted to share the sculptures physically as well as virtually.

The Scottish Poetry Library, in partnership with Edinburgh UNESCO City of Literature Trust, applied to Creative Scotland for funding to tour the sculptures. With the funding awarded, plus a handsome donation from an – appropriately – anonymous well-wisher, we appointed Abby Cunnane as Project Manager. Here's her blog, summing up the 2012 tour as it arrived 'home' at the Scottish Poetry Library.

It's not the conventional idea of a road trip—travelling between five libraries and a book festival in a sturdy white transit van, ten fragile sculptures made of paper in their boxes carefully packed in the back. Between August and December 2012 the GiftED exhibition would visit six venues, including the Central Libraries in Aberdeen and Dundee, the Mitchell Library in Glasgow, the Wigtown Book Festival and the world's first Carnegie library, in Dunfermline.

The trip involved twelve installations and pack-downs, any number of events and workshops, and miles and miles of winding Scottish roads. Sitting in the front of the van, I experienced every bump in the road on behalf of those beautiful and terrifyingly delicate paper sculptures, and felt a profound relief after every unpacking and set up…before doing it all over again.

The boxed sculptures in the van were accompanied by their ten hefty display plinths, by exhibition banners, books and print material, and other boxes containing various tool kits, paint for plinth touch-ups, handling gloves, spirit levels, and all the hundreds of other minuscule things you need to take an exhibition on the road. A conservator came too, checking that the light levels and conditions at each venue were the best possible for their preservation. An entourage: it was hard not to see the sculptures as tiny paper rock-stars on tour.

The tour ended fittingly at the Scottish Poetry Library, and the visitors arrived in droves – over 3,000 of them in a fortnight, which included the first 'Book Week Scotland'. The sculptor, watching from afar (we think – but who knows, maybe close-up?) sent in a little box, with instructions not to open it until 7 December. Alerted by the SPL tweets, a group gathered that morning and saw the box unwrapped and a sculpture of immense charm revealed: a little girl reading a book, with a crown on her head and mary-jane shoes, sitting on Robert Louis Stevenson's *A Child's Garden of Verses*, open at the poem 'To My Mother'. The tree that shades her includes words and lines from Stevenson's poem 'To Willie and Henrietta'. Perhaps this is a very personal sculpture, a tribute to the sculptor's own childhood romance of reading.

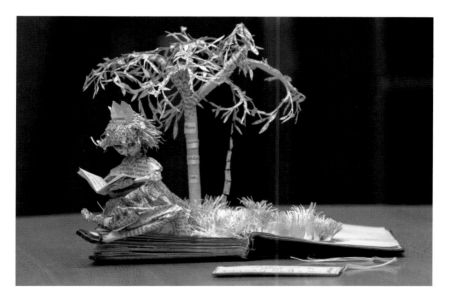

Stevenson's poem to his cousins recalls their games of make-believe, 'all the thousand things that children are', as this sculpture touchingly shows – and how many of those games are inspired by books.

The organisation in Scotland particularly charged with promoting pleasure in reading is Scottish Book Trust, and for Book Week Scotland they commissioned the sculptor (still without meeting her, or knowing where she lives) to make five glorious sculptures based on Scottish classics, which were hidden at various locations around Scotland, with clues to their whereabouts released on Twitter on five successive days. The sculptures featured *Lanark* by Alasdair Gray, 'Tam O'Shanter' by Robert Burns, *Whisky Galore* by Compton Mackenzie, J.M. Barrie's *Peter Pan* and R.L. Stevenson's *Treasure Island*.

We know the story has not reached its end, even at the Scottish Poetry Library. The GiftED sculptures continue to bring in visitors, continue to amaze and delight. On the tag accompanying the little girl reading, the sculptor has written: ' For the Love of Books. Every ending marks a new beginning.'

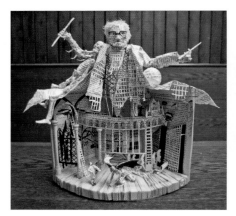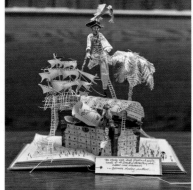

The *Lanark* sculpture – made out of the book that put Glasgow on the imaginative map in 1981 –shows its author, Alasdair Gray, presiding over the Glasgow School of Art, in whose library the sculpture was hidden. *Treasure Island* is instantly identifiable with Long John Silver atop a treasure chest and the marvellous sailing ship in full rig – this one was discovered at the Scottish Seabird Centre in North Berwick.

Tam o'Shanter gallops over the bridge to escape the witches on his tail, who cannot cross the water but take their vengeance on his mare. This sculpture was hidden in the Robert Burns Birthplace Museum in Alloway. J.M. Barrie's birthplace, in Kirriemuir, was the equally apt hiding-place for an evocation of *Peter Pan*, Peter holding out out a hand to Wendy as a crocodile makes its way up the pages. The sculpture based on Compton Mackenzie's classic tale of contraband and the efforts of island folk to conceal it from the authorities, *Whisky Galore* (1947), was hidden in the Am Politician pub on Eriskay – where it was discovered by pupils from the island primary school.

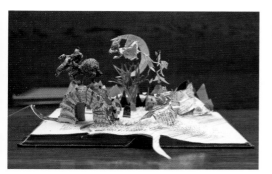

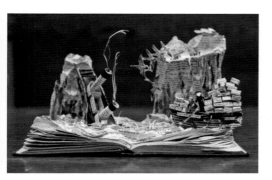

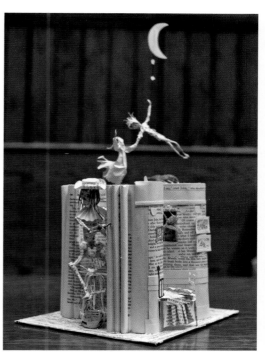

A WORD FROM THE ARTIST One day you wake up and decide that maybe you can do a bit more than sign a petition. (You have, of course, already signed the petition.) What's the point of being a maker, you muse, if now and again you can't use that making to your own ends? And yes, I do mean my own ends.

Many have attributed selflessness to this project, but at its heart is the opposite. At its heart is a profound selfishness. At its heart is a woman, who had been a girl, whose life would have been less rich had she been unable to wander freely into libraries, art galleries and museums.

A woman who, now all grown, still wants access to these places and yes, wants them for her children and maybe one day her children's children.

This project is not a call for stasis. The last thing one wants is stagnation, but it is a tiny shout-out in times of economic difficulties to weigh up the cost before making access to culture more difficult.

THE PLACE: Why Edinburgh? Can you think of anywhere more likely to enjoy a literary mystery?

THE SCULPTURES: In making sculptures from books I saw a pale shadow of the wonder that is reading, where black marks can become scientific theories, romantic poems... gruesome stories. This raises the question 'does a book on being read remain a book?'

And so I chose to transform the books into other things. Sometimes I played with the title. Ian Rankin's *Exit Music* brought to mind a requiem; and his *Hide and Seek*, used for the Writers' Museum's Jekyll

and Hyde also spoke of what we were doing, playing a kind of hide and seek.

At first there was just the one sculpture, the Poetry Library's tree inspired by their strap line 'By leaves we live'. As I went on, I tried to make all the sculptures fit the chosen institutions. The Storytelling Centre was given an iconic dragon; the Filmhouse, a cinema.

The process of making varied from sculpture to sculpture. The idea came first and led the way, then the question of how to realise it. Could it be made solely from paper as with the 'poetree'? Did it need a wire armature? The answer was yes for the T. Rex, Dragon and small figure in Lost.... If you look closely, you will be able to work out how they're all made.

The tag attached to the work also mattered. It was to say something about each piece but also repeat the mantra 'in support of libraries, books, words and ideas'.

Certain writers' work features as a thread winding through the project. This wasn't planned. I used what seemed fitting or could be made to fit but I'm happy that it has turned out to be the case. Edwin Morgan, who bequeathed us a lifetime of wondrous words, often fitted the bill. Having long loved the 'gloves of bee's fur' and 'cap of the wren's wings', I was glad to be able to use Norman MacCaig's 'Gifts' as 10/10. If time had allowed, I'd have made the goblet and cloak also!

Last but certainly not least is Ian Rankin, the only living author I used and pertinent to the project on several levels.

To me Rankin embodies Edinburgh. He lives in and writes of the city. I used *Hide and Seek* for the Jekyll and Hyde sculpture because like RLS, he too reveals Edinburgh in light and shade. Rebus, the central character of the three Rankin novels I used (*Knots and Crosses*, *Exit Music*, *Hide and Seek*) has Edinburgh flowing through his veins. She is his downfall and his salvation. For many folk, the world over, Rebus's Edinburgh is their Edinburgh.

I was fortunate enough to meet Rankin for the first time, though we had exchanged tweets, an hour or so after I had dropped off the very first sculpture at the SPL in March 2011. He was in at the beginning of the story and has been part of it ever since. I always felt the secret was safe in his hands.

There has been a performative element to each sculpture – the placing of the piece in its situation. This had to be done furtively to facilitate a surprise encounter. The work was to be chanced upon, in the way one comes across a book on a shelf, and its altered nature would give it a story.

Why keep it secret/remain anonymous?

Not all mysteries need to be solved and this story belongs to every-one who supports libraries, books, words and ideas…xx

Let no one imagine that the editor of this book has met the sculptor, or knows who she is or where she lives! Our correspondence has been by email, under a pseudonym on her part. When asked whether she had any initial sketches for the sculptures, she produced beautifully detailed instructions on how to make a 'poetree'. She kindly wrote the piece about the sculptures and her motivation for making them, and even drew the map that appears on the endpaper. Although she says that this is not a story of selflessness, this series of sculptures and the accompanying work you find in this book has been produced not as a commission but in the service of an ideal, as a celebration and a reminder that we should share our gifts.

WHY NOT MAKE YOUR OWN POETREE?

gather together...

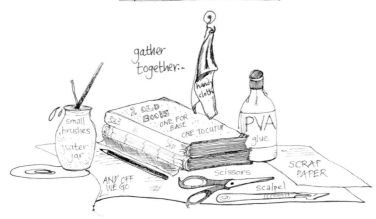

small brushes
water jar
handy cloth
2 OLD BOOKS
ONE FOR BASE
ONE TO CUT UP
PVA glue
AND OFF WE GO
Scissors
SCRAP PAPER
scalpel

THE TRUNK

· · · · Using your most damaged book
decide on the diameter of your tree trunk.
...Using a compass or a handy lid draw discs (5cm works well)
... You will find your own technique for cutting.
... Scissors are fine and fast speed cut through
as many layers of paper at a time as you can manage.
... You will need many, many discs....
··· Spread P.V.A onto surface of disc and build upwards.

You will need to build the trunk up in stages and allow for drying time otherwise your paper tower becomes very unstable.

[NB] Make the trunk tall enough so that the bottom can be sunk into base.

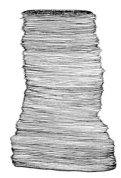

By cutting slightly smaller discs you can taper the trunk as you progress

irregularities add charm

BRANCHING OUT

WHEN YOUR TRUNK IS TALL ENOUGH YOU CAN CONSIDER BRANCHING OUT

When you have worked out your shapes - cut enough to build up 1cm or so...

Obviously you won't want the branches to stick straight up.... so

VIEWED FROM ABOVE

glue the branch shapes off centre decreasing in size gradually

VIEWED FROM ABOVE
To form branches cut 2 or more shapes that will fit within the main trunk...
I am showing 2 for simplicity but feel free to go for a more advanced version

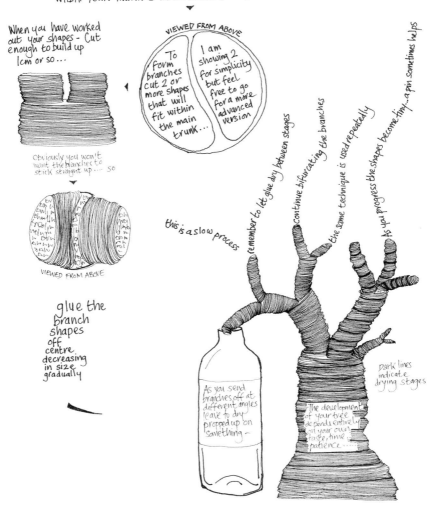

this is a slow process

remember to let glue dry between stages

continue bifurcating the branches

the same technique is used repeatedly

as you progress the shapes become tiny...a pin sometimes helps

Dark lines indicate drying stages

As you send branches off at different angles leave to dry propped up on something -

The development of your tree depends entirely on your own taste, time, patience......

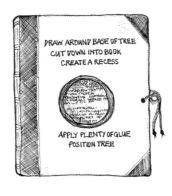

DRAW AROUND BASE OF TREE
CUT DOWN INTO BOOK
CREATE A RECESS

APPLY PLENTY OF GLUE
POSITION TREE

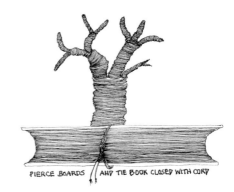

PIERCE BOARDS / AND TIE BOOK CLOSED WITH CORD

DECORATION
paper cutting

- Now the tree is growing out of your book it is time to add the finishing touches.
- Take either text or coloured magazine pages and by gluing pages together make two ply sheets
- Then with only your imagination to limit you decorate the tree with fine branches, leaves, flowers, birds, butterflies, fairies....

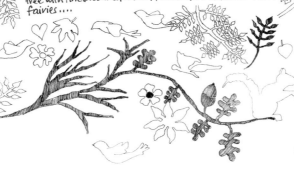

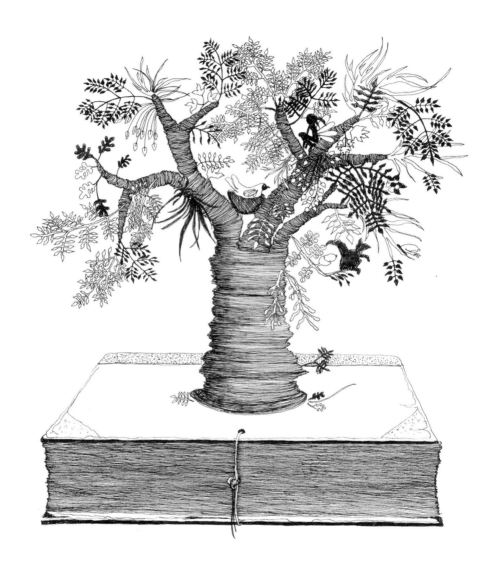

THE END